from the Deep Waters

Maidens of Myth and Mystery

Essay by

Toshiyuki Takamiya

CHRONICLE BOOKS

SAN FRANCISCO

First published in the United States in 1996 by Chronicle Books.

First published in Japan in 1993 by Treville Co., Ltd.

Printed in Hong Kong.

ISBN 0-8118-1485-8

Library of Congress Cataloging-in-Publication Data available.

Text and cover design: Sarah Bolles
Book design: Milky Isobe

Distributed in Canada by
Raincoast Books
8680 Cambie Street
Vancouver, B.C. V6P 6M9

10 9 8 7 6 5 4 3 2 1

Chronicle Books
275 Fifth Street
San Francisco, California 94103

SIGHS
OF

WATER

OPHELIA

Arthur Hughes

There is a willow grows aslant the brook, That shows his hoar leaves in the glassy stream: there with fantastic garlands did she come. Of crow-flowers, nettles, daisies, and

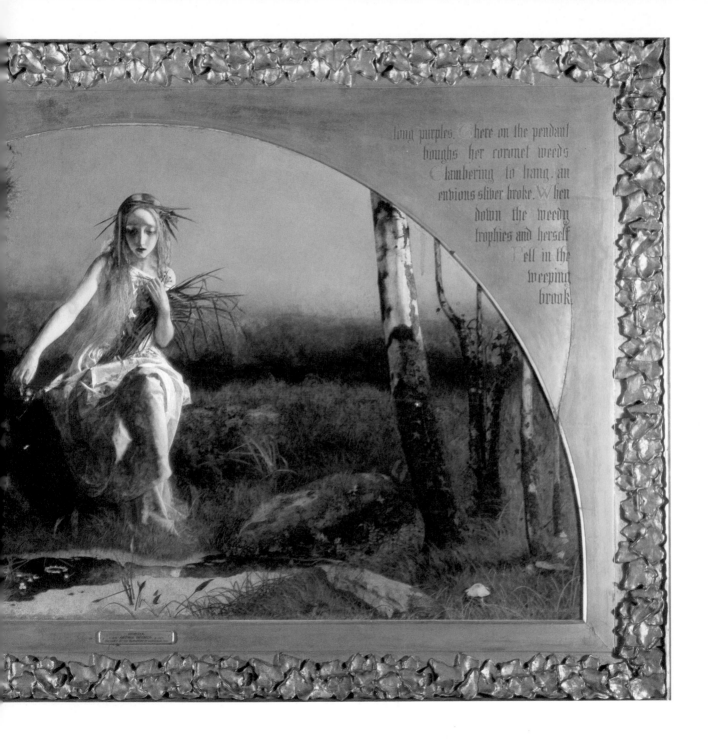

long purples. There on the pendant
boughs her coronet weeds
Clambering to hang, an
envious sliver broke. When
down the weedy
trophies and herself
Fell in the
weeping
brook.

OPHELIA — AND HE WILL NOT COME BACK AGAIN

Arthur Hughes

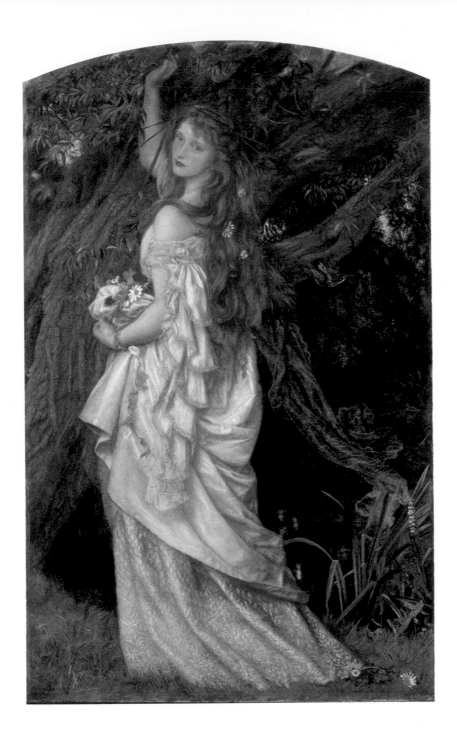

OPHELIA

John William Waterhouse

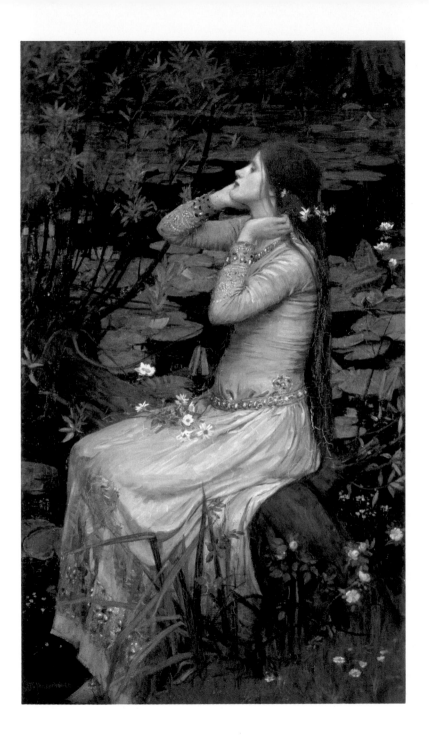

OPHELIA

George Frederic Watts

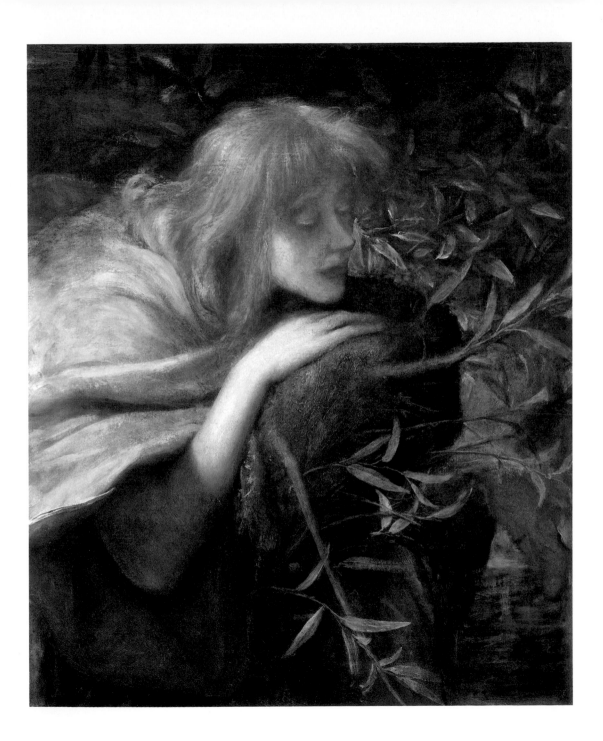

OPHELIA

John Everett Millais

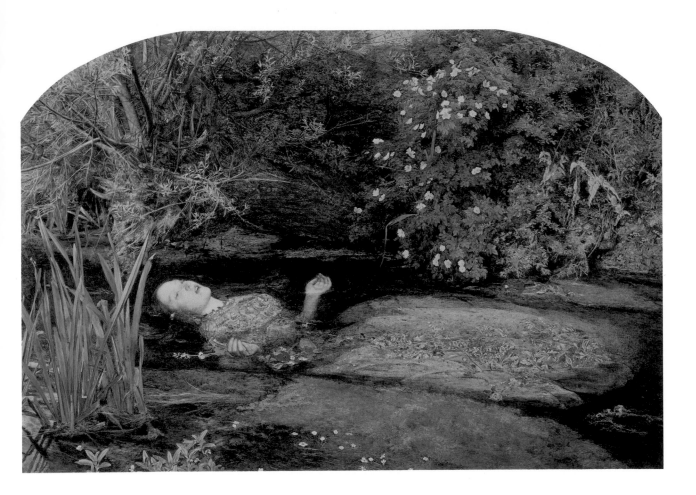

THE DEATH OF OPHELIA

Eugène Delacroix

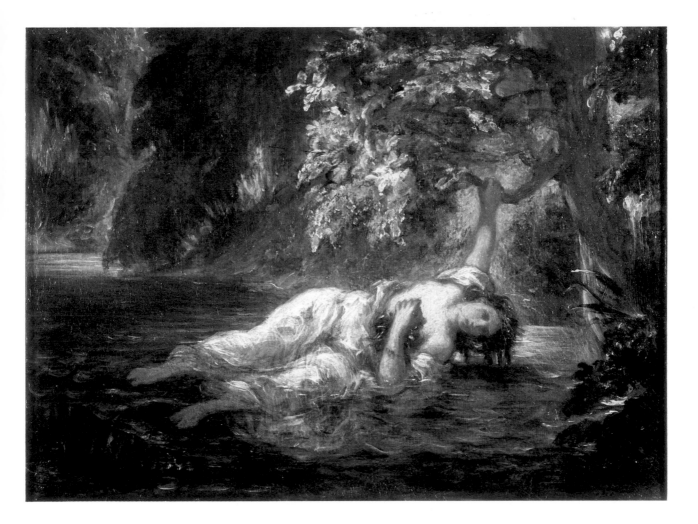

OPHELIA

Paul Steck

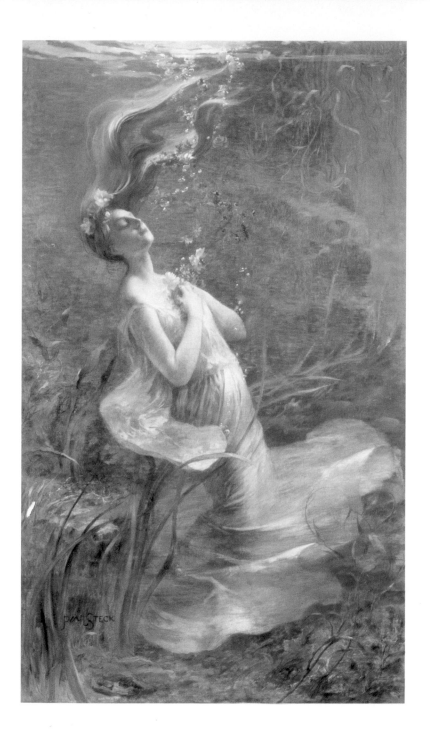

ELAINE

Gustave Doré

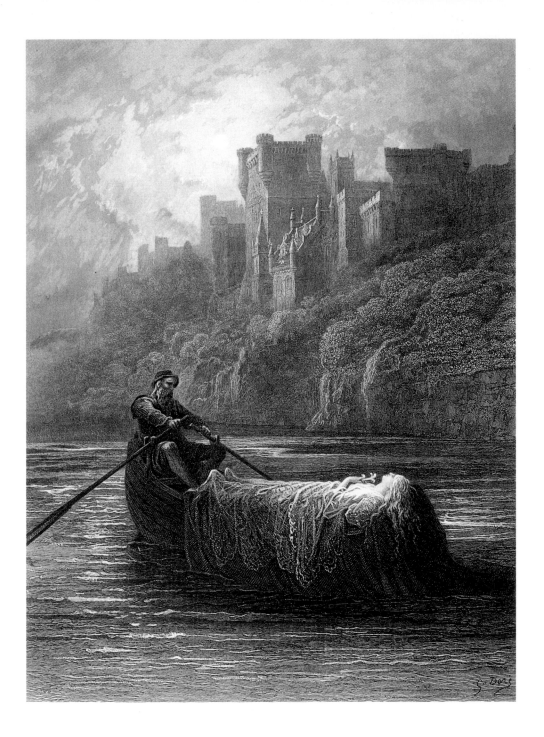

ELAINE

John Atkinson Grimshaw

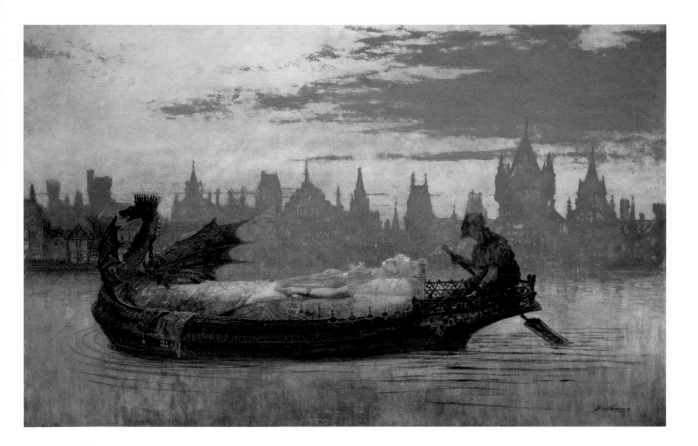

THE LADY OF SHALOTT

John William Waterhouse

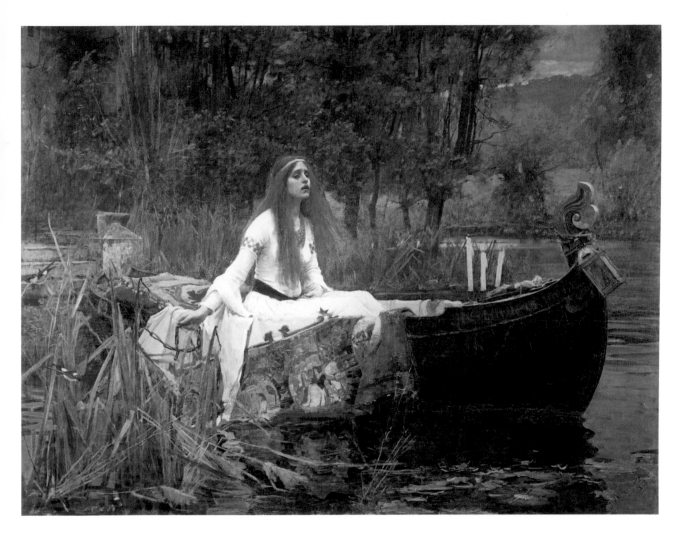

THE LADY OF SHALOTT

John Atkinson Grimshaw

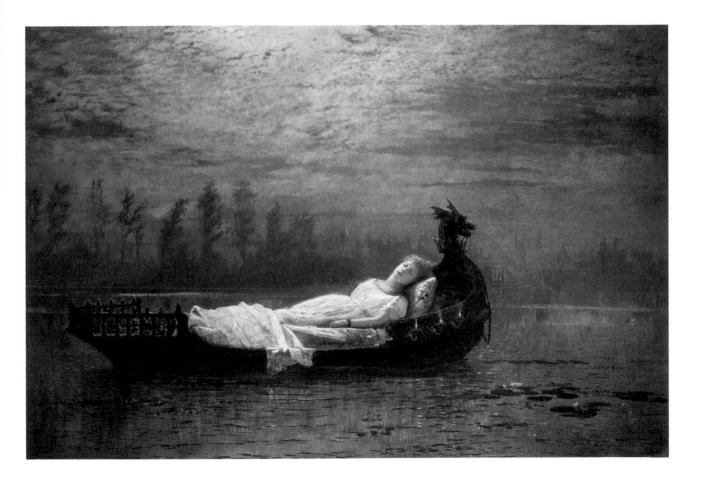

LA JEUNE MARTYRE

Paul Delaroche

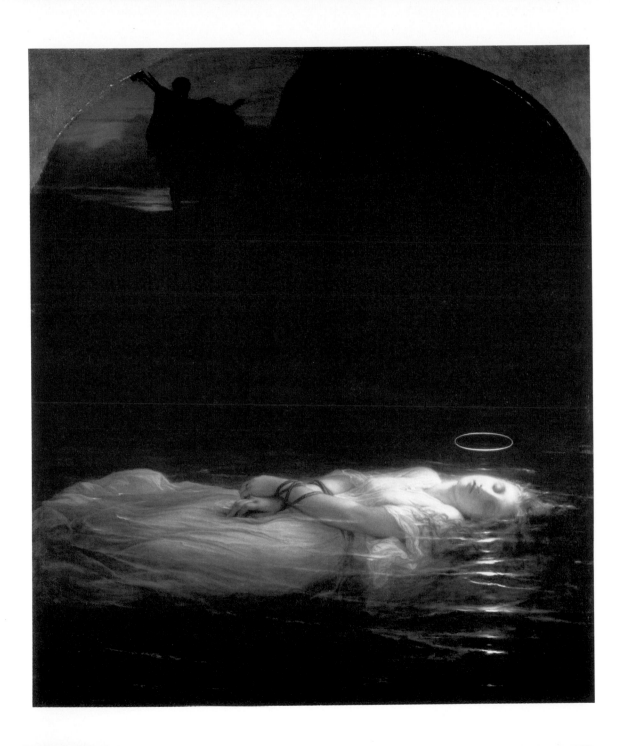

THE BRIDGE OF SIGHS

Gustave Doré

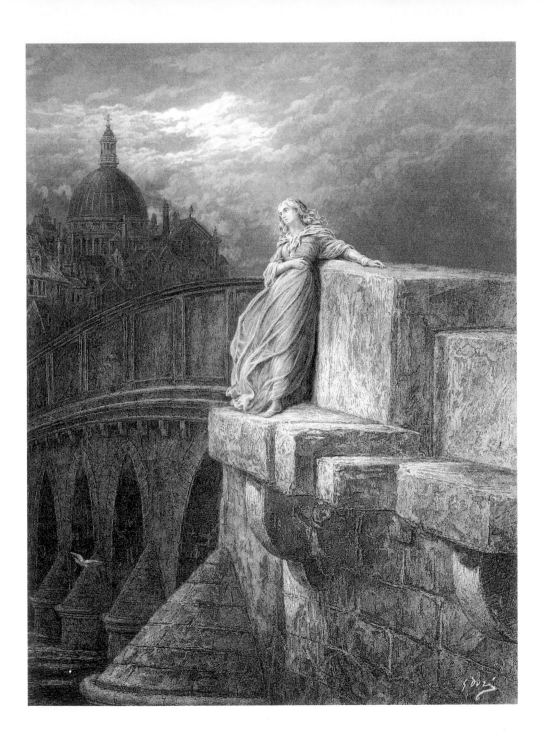

PAST AND PRESENT NO. 3

Augustus Egg

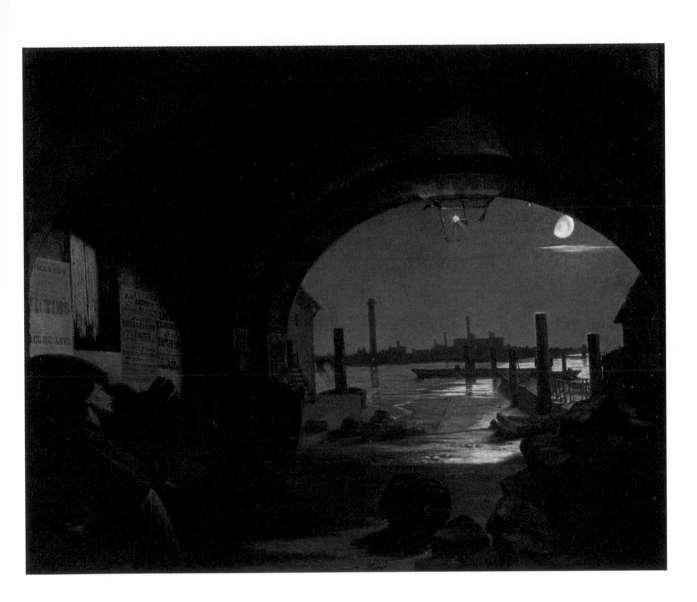

John William Waterhouse

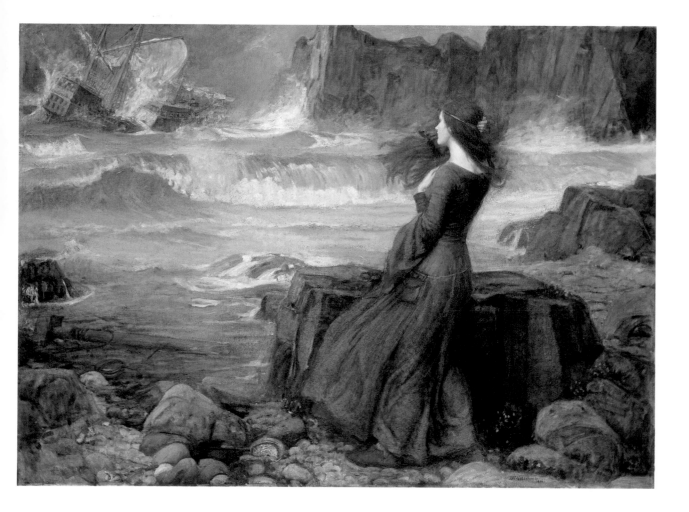

WATER
NYMPHS

Hylas and the Nymphs

John William Waterhouse

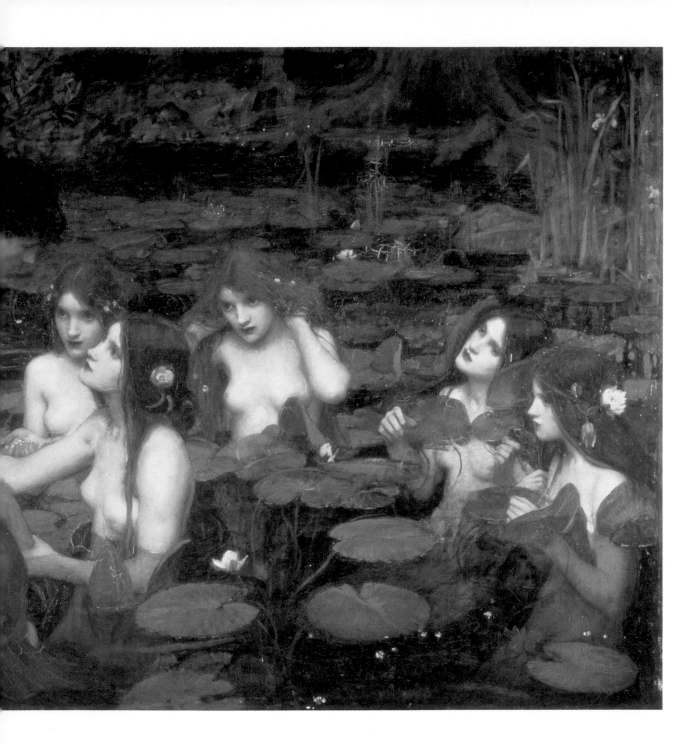

THE BEGUILING OF MERLIN

Edward Burne-Jones

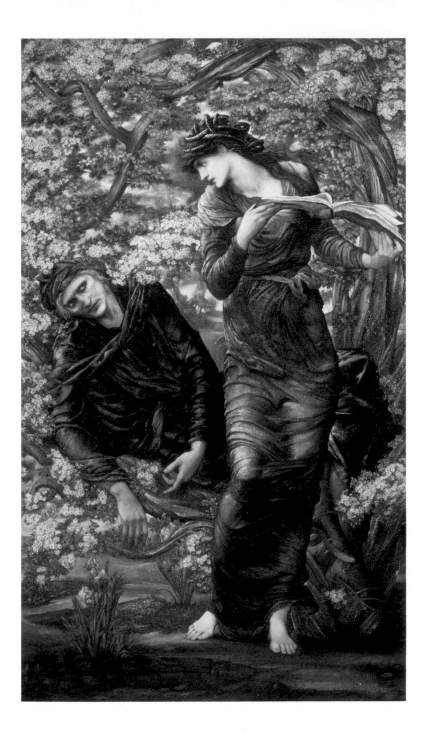

STUDY FOR NYMPHS FINDING
THE HEAD OF ORPHEUS

John William Waterhouse

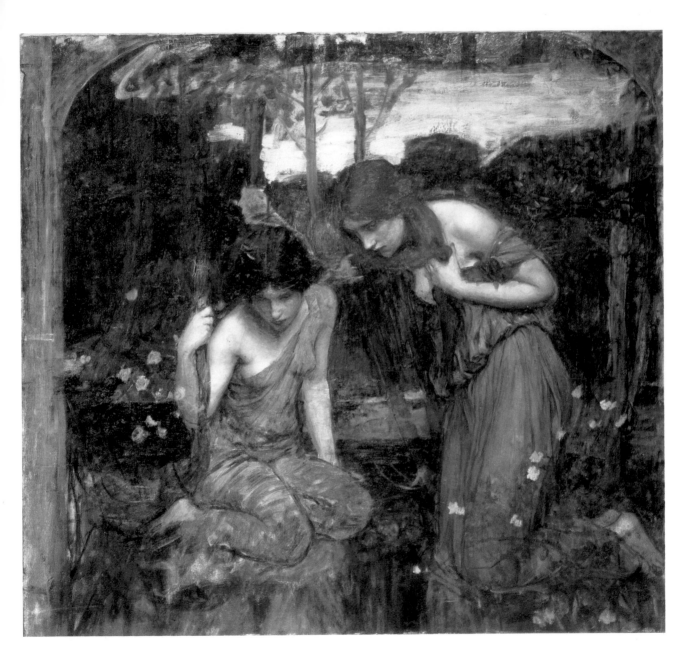

ECHO AND NARCISSUS

John William Waterhouse

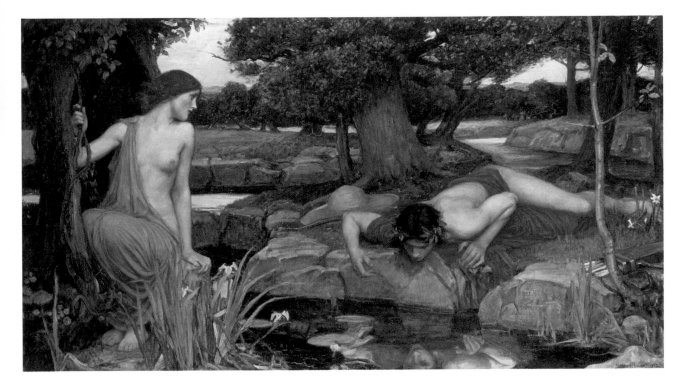

THE DANAÏDES

John William Waterhouse

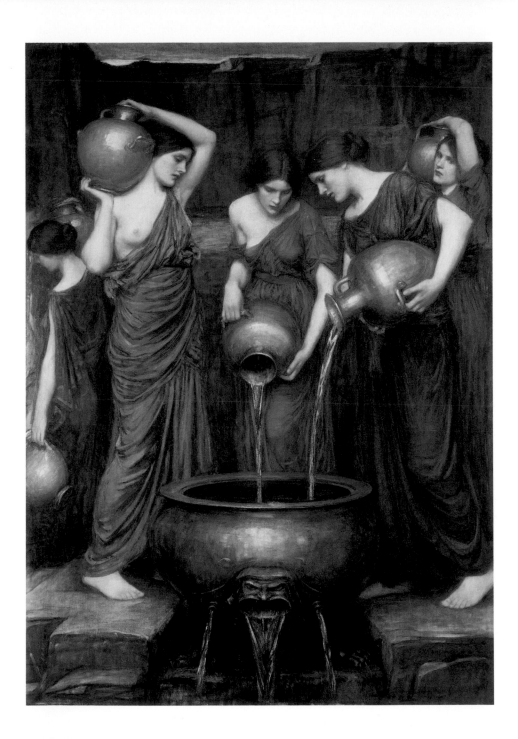

Kelpie

Herbert James Draper

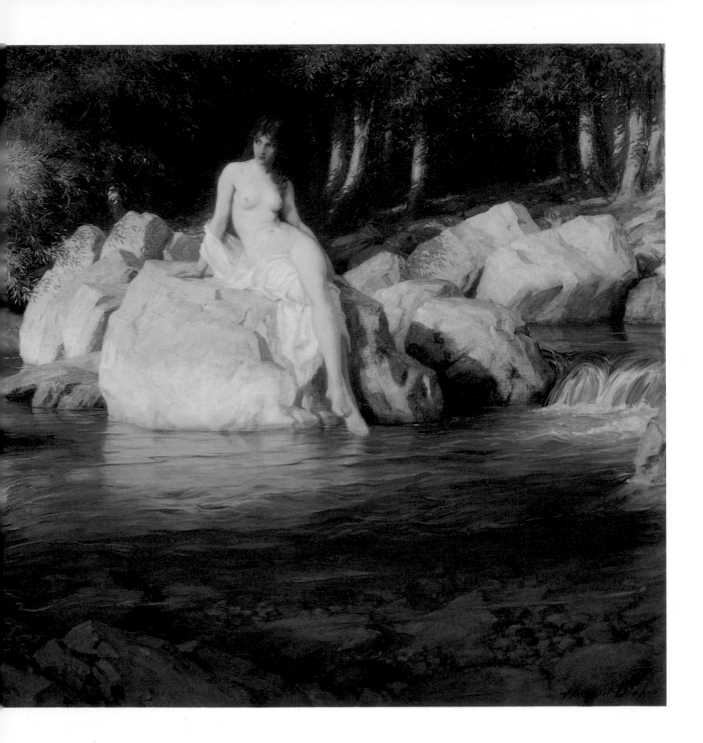

CIRCE AND SCYLLA

John Melhuish Strudwick

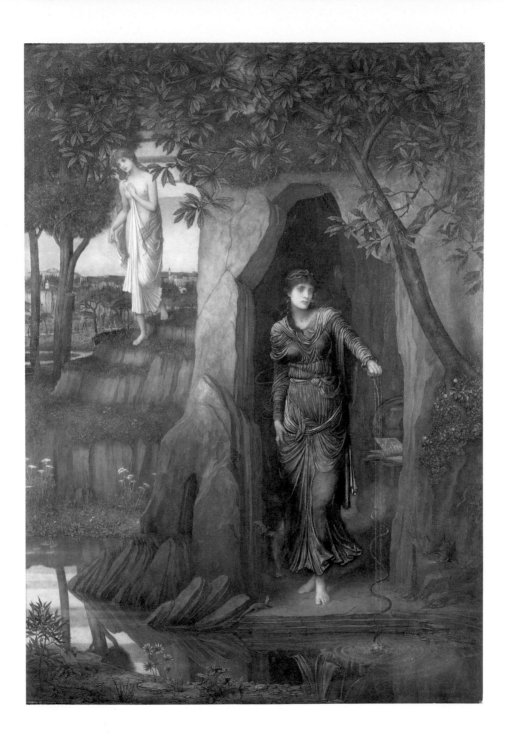

CIRCE INVIDIOSA

John William Waterhouse

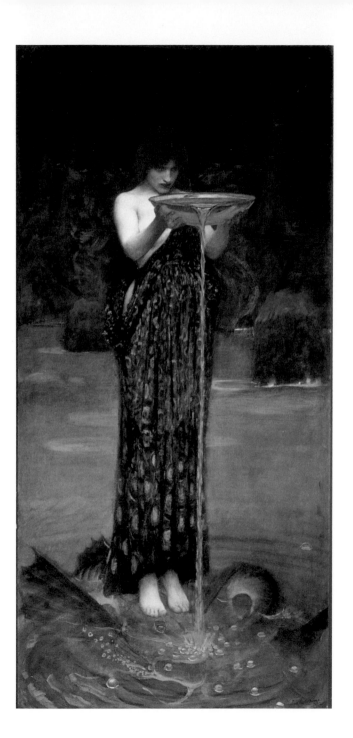

MEDUSA

Lévy-Dhurmer

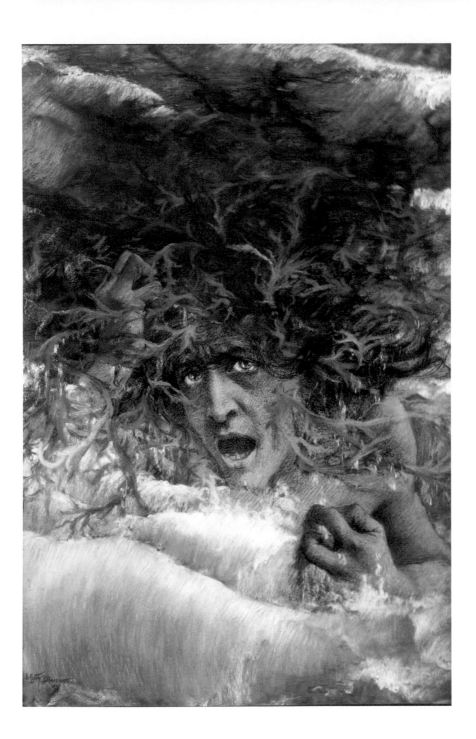

WATERSNAKES

Gustav Klimt

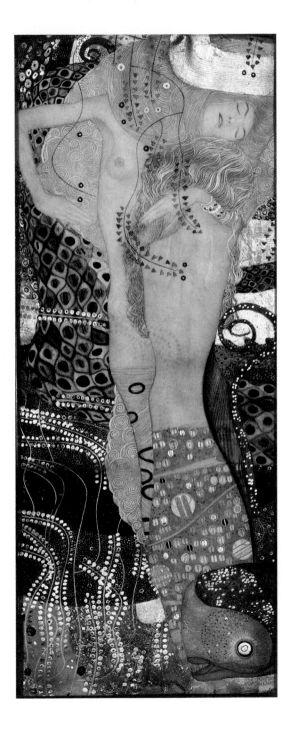

GOLDFISH

Gustav Klimt

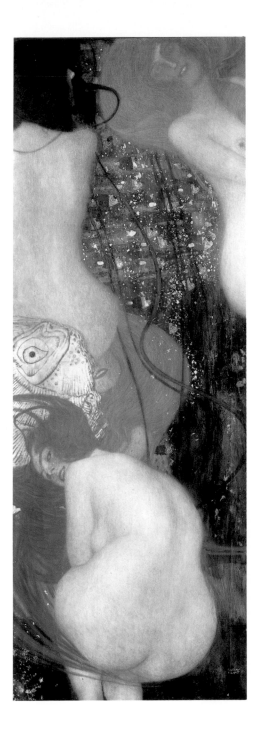

FROM THE
DEEP

THE MERMAID

John William Waterhouse

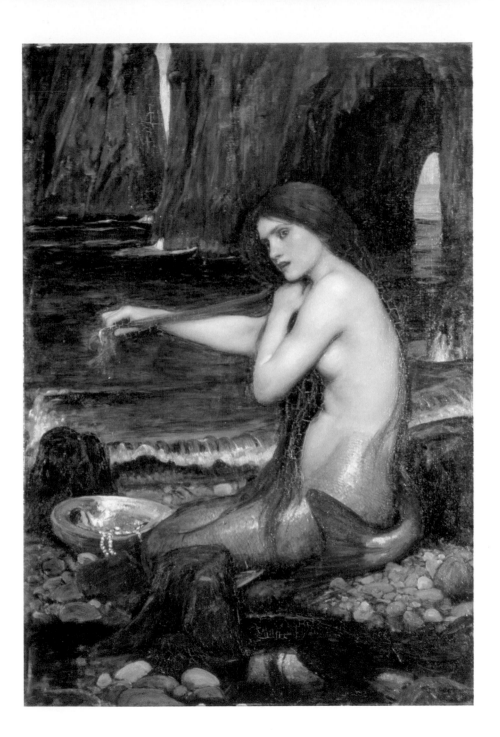

CALM SEA

Arnold Böcklin

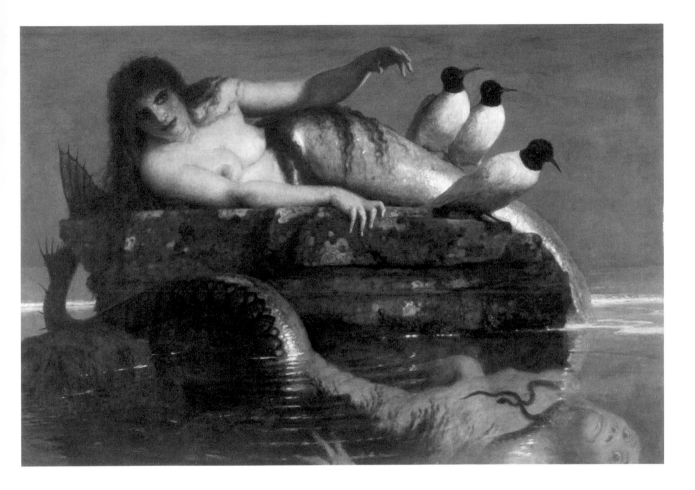

THE DEPTH OF SEA

Edward Burne-Jones

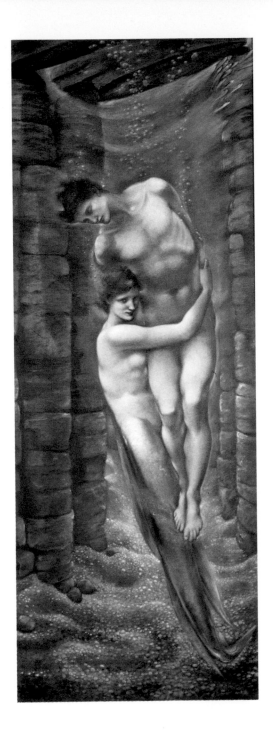

THE SIREN

John William Waterhouse

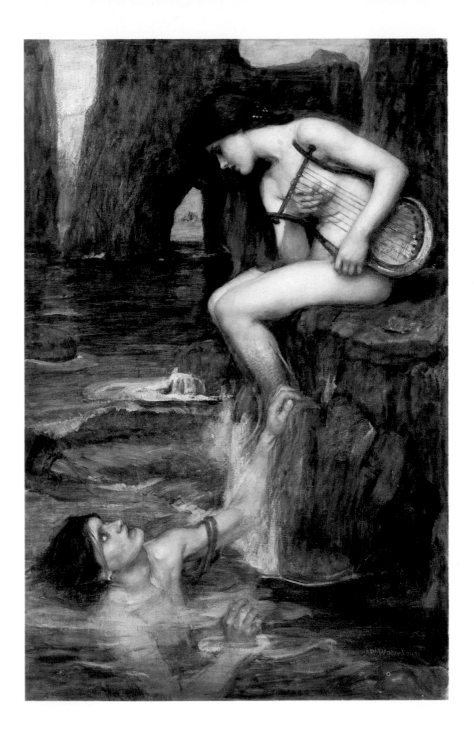

STUDY FOR THE SIRENS

Edward Burne-Jones

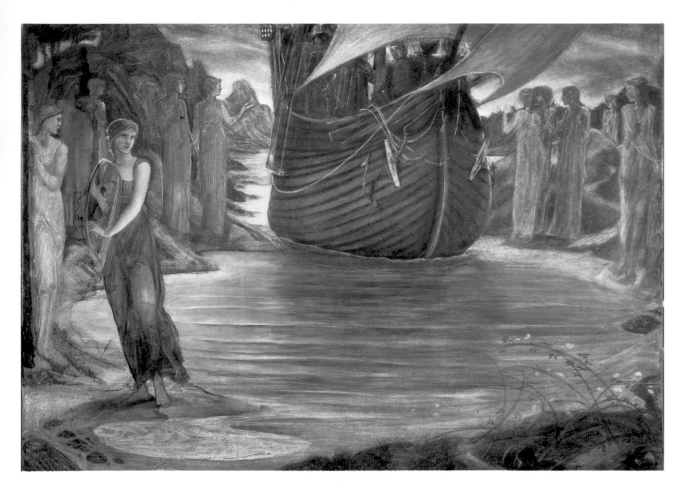

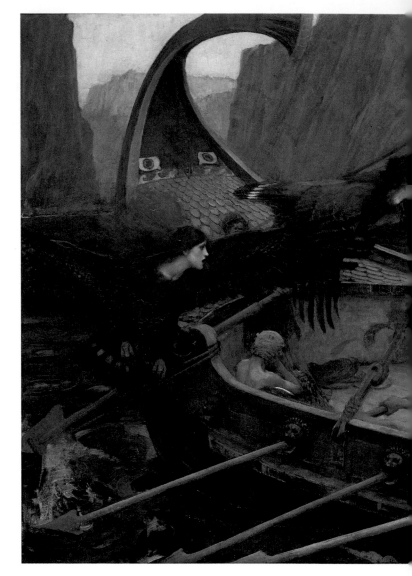

ULYSSES AND THE SIRENS

John William Waterhouse

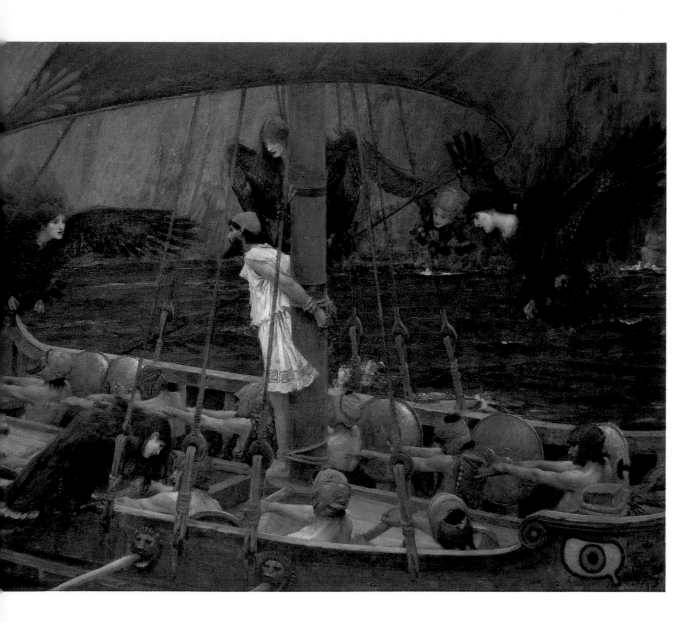

U L Y S S E S A N D T H E S I R E N S

Herbert James Draper

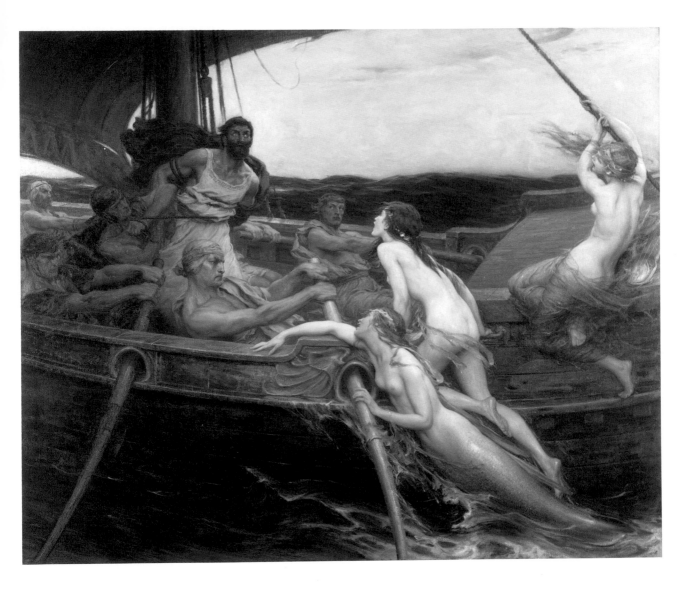

THE FISHERMAN AND THE SIREN

Frederick Lord Leighton

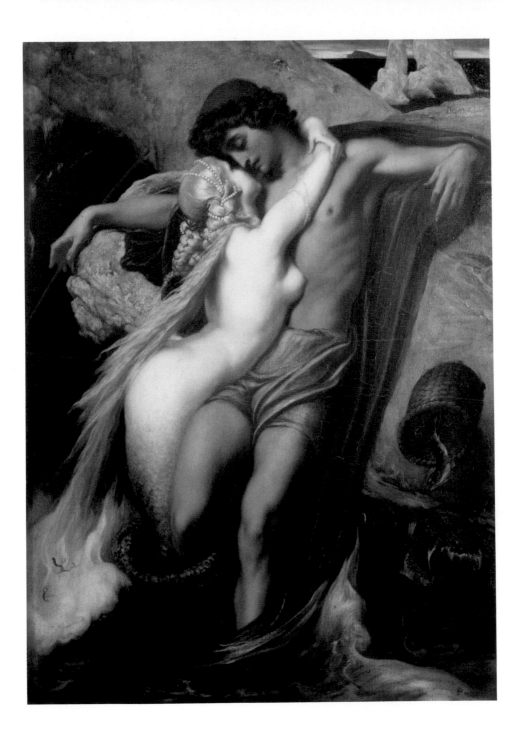

WATER
BLOOMS

SYRINX

Arthur Hacker

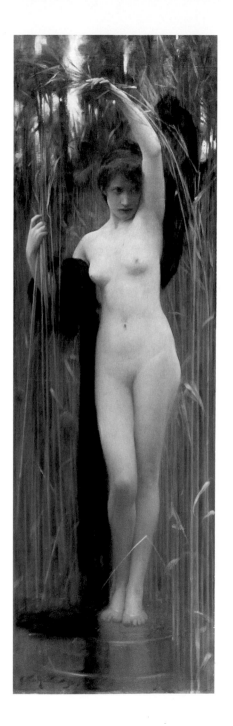

PERSEUS AND ANDROMEDA

Frederick Lord Leighton

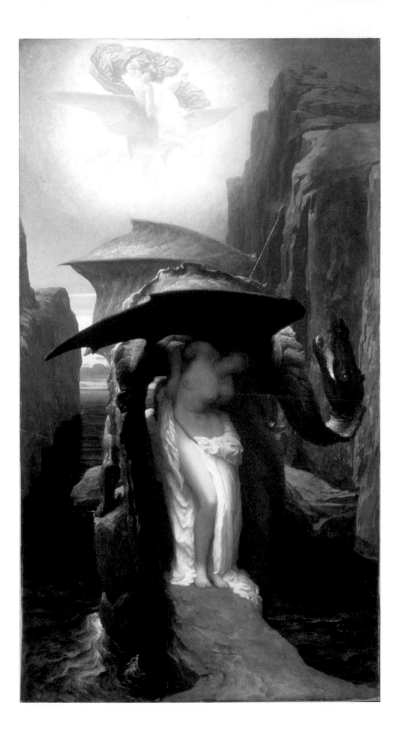

A WATER BABY

Herbert James Draper

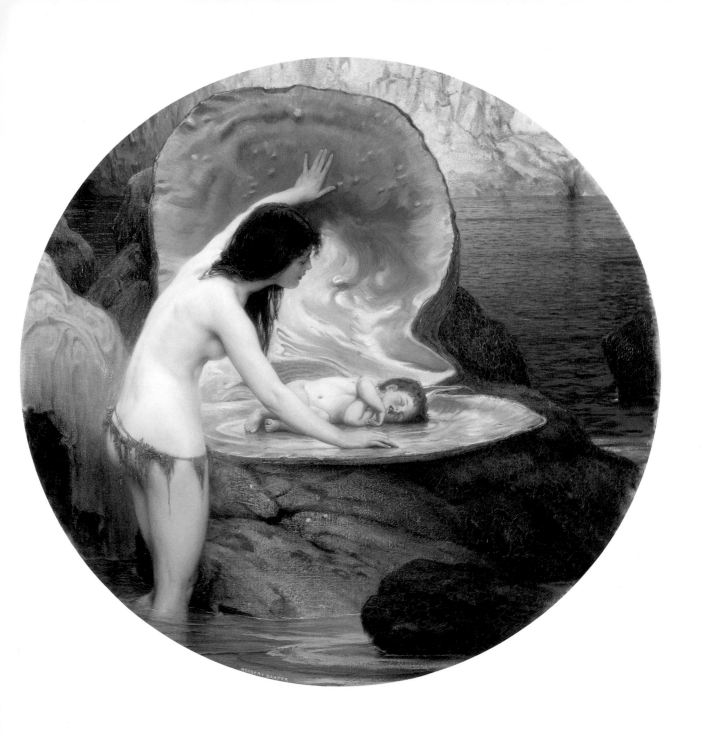

THE LAMENT FOR ICARUS

Herbert James Draper

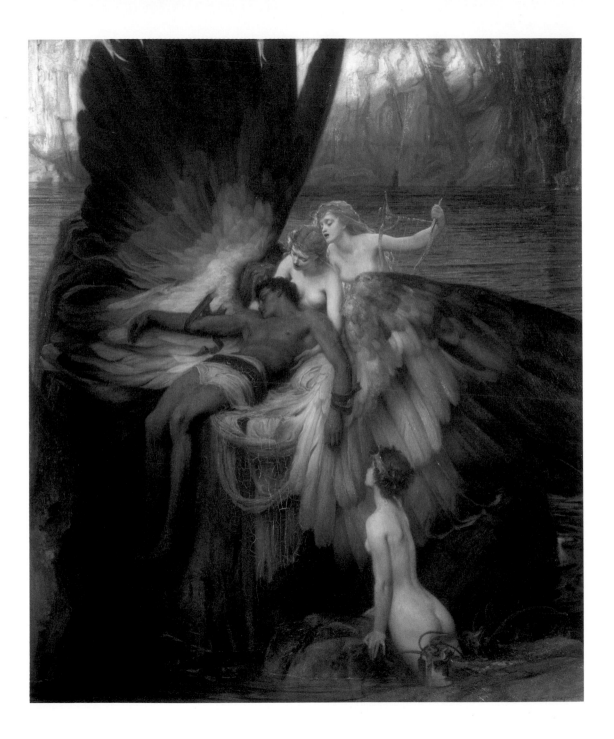

COME UNTO THESE YELLOW SANDS

Richard Dadd

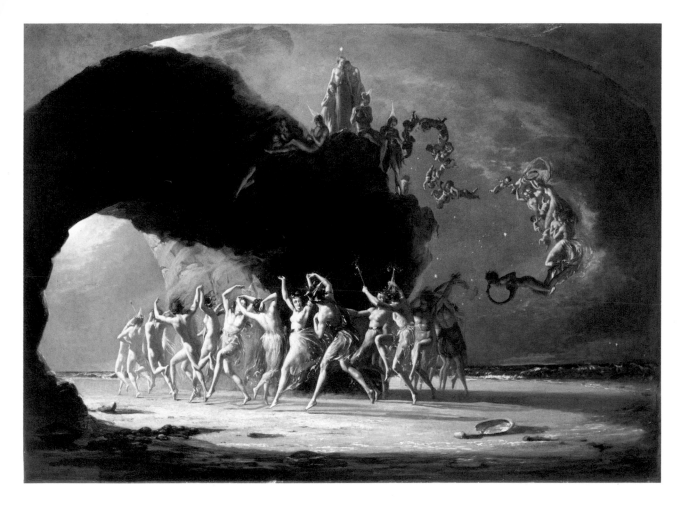

THE BIRTH OF VENUS

Alexandre Cabanel

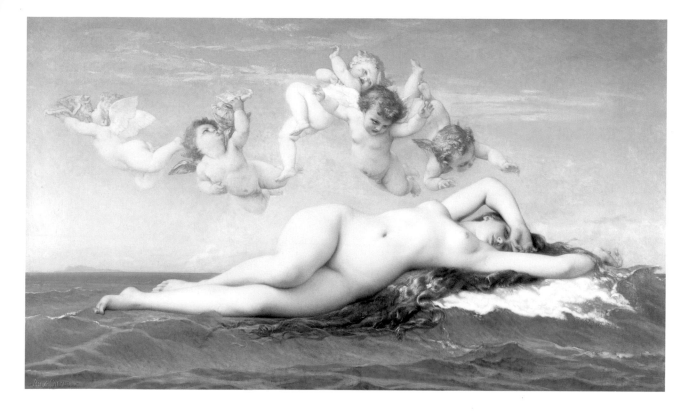

THE BIRTH OF VENUS

Charles Shannon

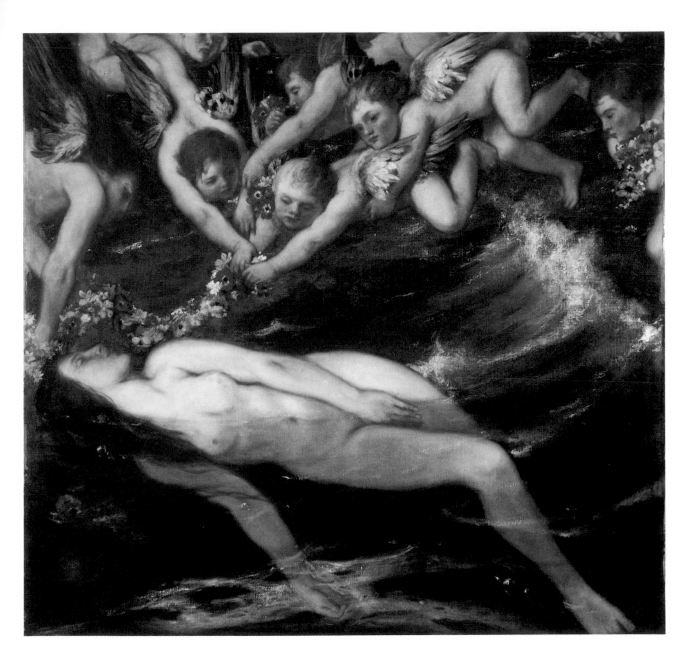

THE BIRTH OF VENUS

William Bouguereau

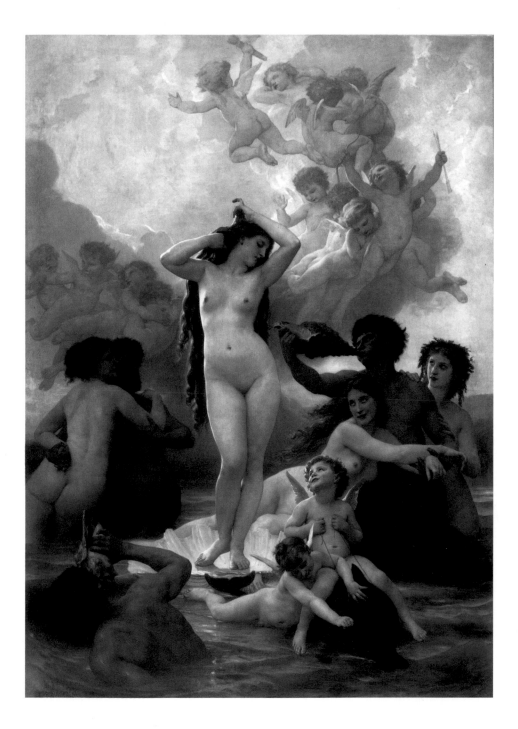

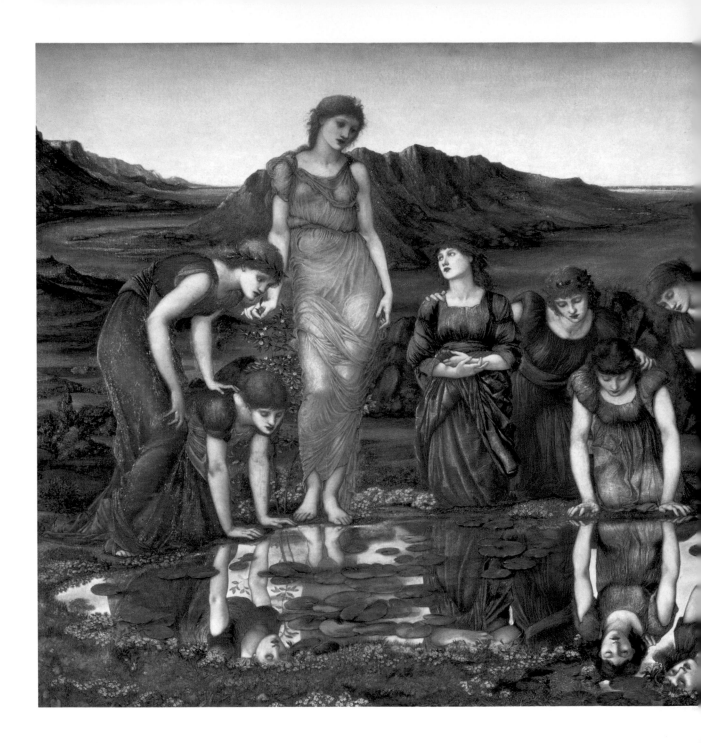

THE MIRROR OF VENUS

Edward Burne-Jones

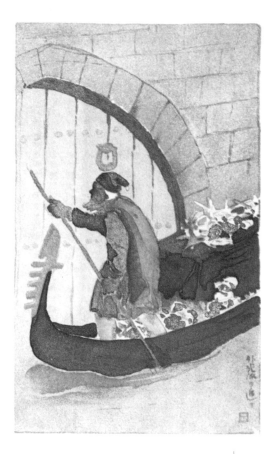

FROM THE DEEP WATERS

Toshiyuki Takamiya

from the DEEP WATERS

Toshiyuki Takamiya

I once heard a famous painter say on the radio that if visitors to an exhibition stop in front of a picture and look at it for ten minutes, it must be a masterpiece. When I thought about this from the painter's point of view, I could well understand how he would like to paint something to which we would want to devote ten full minutes. With some pictures, of course, it would be easy to spend ten minutes just looking, without paying close attention; but there are other works that seem to require time for the viewer to think more deeply. This is true of pictures that tell a story, as well as of those that involve symbols.

Take, for example, John William Waterhouse's 1888 painting *The Lady of Shalott,* reproduced in this book (page 23). Let us look at it for a moment without worrying about the title. The painting shows a young woman with long red hair dressed in white, sitting alone in a small boat. She has just unfastened the chain of the mooring and is about to set off, looking as if she is about to cry. Her figure stands out strikingly against the beauty of nature around her, her long white sleeves contrasting effectively with the dark colors of the boat and the background. The painting attracts our attention, arousing curiousity about this ethereal figure.

Whether for its subject matter of woman and water, its strong emotional content, or its large size (60 x 79 inches), this is the sort of painting that might easily hold our attention for ten minutes. Yet the longer we look at it, we notice more of the carefully added details and we are likely to have more questions about it. Is it autumn, we wonder? Is it dusk? Is the small figure on the prow a statue of Christ? What is the meaning of the three candles, only one of which is lit? What is the fabric hanging over the sides of the little

boat? And does the inscription "The Ladie of Shalott" on the ship refer to the woman? Why is this painting called *The Lady of Shalott*?

If you asked yourself questions like these as you looked at the painting, then you have become caught up in its narrative quality and will want to know some answers. If you continue to examine the painting, these questions may give rise to further questions, such as why the woman is wearing a white costume, or whether untying the chain could be a symbol of release from a spell or bondage of some kind. What might be the meaning of the dead leaves floating on the water in the foreground, or of the withered plants? And the two small birds flying along the lower left edge, what might they symbolize?

Ten minutes will pass by very quickly if you consider all the obvious questions that come into your mind as you study this painting, if *study* is the right word.

Here is some information that may be of some help for those who are puzzled looking at Waterhouse's *The Lady of Shalott* for the first time. The English painter John William Waterhouse (1849-1917) has become very popular over the last few years, even though there has never been a large-scale exhibition devoted to his work. Throughout his career, he used the same few women as models in his treatments of classical literature, mythology, and legend—a fascination he owed to his childhood years spent in Italy, where he was born. With their vivid colors and strong emotional content, his paintings are a natural choice for inclusion in this book.

There is a strong sense of narrative in Waterhouse's paintings, as in those of Edward Burne-Jones and some other painters of the time. Although Waterhouse is often regarded as a latter-day follower of the Pre-Raphaelite movement, he has been described as a romantic classicist by his biographer Anthony Hobson. Waterhouse made many paintings of literary figures such as Tennyson's Lady of Shalott and Shakespeare's Ophelia. Of his three well-known treatments of the Lady of Shalott, the one reproduced here was the first to be completed and remains the most famous. Now in London's Tate Gallery, Waterhouse painted it in 1888 with his wife as model. The work is naturalistic in technique, but rich in symbolism.

Tennyson's poem was a great inspiration not only to Waterhouse and William Holman Hunt, but to painters of the Victorian period generally. Published in 1832 when Tennyson was twenty-three years old, and again ten years later in an extensively revised version, it is a narrative poem consisting of four sections that reflect the changing seasons. In this mysterious story, which Tennyson vividly describes in melodious language, a woman is confined to a room in a tower on the island of Shalott, in the middle of a river that flows toward Arthur's court of Camelot. Day and night she weaves on a loom, forbidden to look from her window by threat of a curse. She can only see the outer world reflected in a mirror on the wall, and she must weave all she sees. She has long worked hard without thinking about the curse, but then a pair of young newlyweds goes past. "I am half-sick of shadows," she cries. At that moment, the knight Lancelot comes riding up, gallantly clad in armor. The Lady of Shalott can bear it no longer and runs to the window. When she sees him, her loom flies up and floats in the air, and the mirror cracks. "The curse is come upon me," she cries, and she climbs down from the tower to the river where she finds a boat. She writes her name on its prow, lays herself down, and lets herself be carried away by the flow of the river. After singing one last song, she dies. When her dead body drifts ashore at Camelot, all who see it are seized with fear except Lancelot. He thinks for a time then says, "She has a beautiful face; God in his mercy lend her grace, the Lady of Shalott."

As this summary indicates, Tennyson does not explain why the Lady of Shalott is under a spell; and because so much about her was left to the reader's imagination, the original poem was a great inspiration to painters. Waterhouse's 1888 painting is a visualization of these lines from the fourth section of the poem:

> *And down the river's dim expanse*
> *Like some bold seer in a trance,*
> *Seeing all his own mischance—*

With a glassy countenance
Did she look to Camelot.
And at the closing of the day
She loosed the chain, and down she lay;
The broad stream bore her far away,
The Lady of Shalott.

While Waterhouse transferred the story in the poem to canvas with considerable fidelity, he also reinterpreted it, adding details from his own imagination: The woman has never known a man. Her snowy white costume shows her innocence, yet it could also be thought of as death attire. According to some critics, other things that represent her virginity are her long, loose hair, her tightly-fitting medieval costume, her pearl necklace, and the water lilies in the foreground.

 The girl is sitting in the middle of the boat, loosening the chain. This is important for it symbolizes her escape from confinement in the castle of Shalott and her liberation from the curse. It is also clear that the figure of a woman weaving at her loom is a symbol for an artist absorbed in creative work. The poem describes how "round about the prow she wrote / The Lady of Shalott." Waterhouse makes it look like an artist's signature. In a bold reinterpretation of the poem, he has her bring to the boat the artistic work of her own creation, the woven fabric she sacrificed in exchange for love. Into it she has woven scenes of the everyday world she desires. No other painter interpreted the poem in such a remarkable way.

 The fact that Waterhouse gives the word *Lady* the archaic-looking spelling *Ladie* suggests he was aware that the poem is based on the medieval tales of King Arthur. And, certainly one reason the tale is wrapped in such a mysterious atmosphere is that the woman is not given any name of her own, Shalott being the name of a place.

 From Tennyson's use of the expression "glassy countenance," we are to understand that she is in a state of trance, close to insanity. Her mouth is

half-open; her gaze unfocused. Dante Gabriel Rossetti and the other Pre-Raphaelite painters often depicted young women in this extremely sensual way. Does her expression reveal intoxication with love? Or despair? Is she vacantly gazing in the direction of Camelot and her beloved Lancelot? Or perhaps she is singing her last song, a swan song on her journey to death.

The crucified Christ figure on the prow of the boat and the three candles (two already blown out by the strong wind) represent the ordeal that she is suffering and show that this voyage will be her final journey. They are not mentioned in the original poem, although there is a crucified figure of Christ by the window in Elizabeth Siddal's 1853 pen-and-ink-drawing, *The Lady of Shalott*. In William Holman Hunt's famous *Lady of Shalott* of 1905 there is not one candle left in the candlestand, so does one candle burning here mean that there is still hope left? Surely not. It is the last candle, burning in the face of a strong wind, so it, too, will soon come to an end, just like her life.

You might have noticed a reddish brown maple leaf on the right leg of the woman in white. The poem describes "leaves upon her falling light," hinting with the word *falling* at the woman's ruin and death. Many more leaves have fallen on her in the 1888 painting by John Byam Liston Shaw, which depicts her writing her name on the prow of the boat.

In considering the lady's fall, it is worth mentioning the suggestion by one critic that in the rhyming words *came, dame,* and *name* of the next to last stanza, we can hear an echo of the word *shame*. In this reading the lady of Shalott is a fallen woman, a woman who has yielded to strong sexual temptation. Another critic disagrees, asking why it must be shame and arguing that it would be equally possible to hear a reference to the artist's fame. Whether the Lady of Shalott is regarded as an innocent virgin fighting against solitude, as a mysterious creature under a curse weaving a magic web, or as a fallen woman, she may well be called a martyr of love because she gives up her life in exchange for love for Lancelot.

"Heavily the low sky raining" are the words of the original poem, but Waterhouse creates a break in the rain clouds so that light pours down from

the setting sun of the late autumn day, accentuating the dead leaves floating on the surface of the water and the withered reeds that hint at her ultimate fate. The feminine ideal is represented by the two small titmouse-like birds flying freely about the reeds.

A painter who transforms a poem into a painting must be allowed a certain amount of discretion to reinterpret when the poem contains a passage of time and the painting does not, as in this case. One might, perhaps, give the example of how a conductor and musicians interpret a composer's score, producing music for the audience. In literature, however, a great work begins to have a life of its own as soon as it has left the hand of the writer, who can do nothing to prevent people interpreting it freely. This is true of poems like Tennyson's "The Lady of Shalott" and the closely related "Elaine," which inspired more than thirty paintings in the Victorian period alone. The same thing may also be said of great works of art, for we have the right to "read" a painting and interpret it as we like. There are, of course, great differences in ways of reading depending on the period and individual. If everyone has the right to read paintings as he or she likes, then it is hardly strange to spend ten minutes on one painting.

John Everett Millais's *Ophelia* of 1851 is probably one of most popular Victorian paintings on display in the Tate Gallery, but recently Waterhouse's *The Lady of Shalott* has become equally popular. Crowds of people always surround the painting, and gallery talks are sometimes given about it. Glance into the gallery's bookshop, and you will find the same thing. Postcards and posters of *The Lady of Shalott* are best-sellers, selling as well as those of *Ophelia*. The painting is used for the design of T-shirts, and there is even a Cat Lady of Shalott based on Waterhouse and designed by a contemporary painter.

These two works by Waterhouse and Millais have several points in common: inspiration from a literary work, unrequited love, a young woman, water, and finally, death. That the woman goes to her death singing is also something they share. In Shakespeare's tragedy, when Ophelia is rejected by her love Hamlet, she becomes mad and drowns. As is indicated by the

number of paintings of Ophelia included in this book, this scene moved Romantic painters greatly. In the play, her death is not represented, but is only described by Hamlet's mother. In spite of this fact—or rather because of it—her death scene inspired many artists.

John Everett Millais (1829-1896) was a founder of the Pre-Raphaelite movement and one of the most successful painters in nineteenth-century England. He had been a child prodigy, but by the time he painted *Ophelia,* he was twenty-three and able to demonstrate his full artistic skill. Praised by the critic John Ruskin for the accuracy of its depiction of nature, the painting illustrates the flowers and plants connected with Ophelia with great attention to appearance, as well as to symbolism. Since the iconography of this master-piece is discussed in many art books, there should be no need to analyze it again here. Instead, what is important to note is how model Elizabeth Siddal's hair and clothing, partly visible on the river surface, are being dragged under the water so as to become one with the water plants. Millais, who regarded death as a beautiful or romantic thing, has captured the last moment in the life of a girl who died for love as she becomes one with the water around her. The green of the freshly budded plants and the spring anemone contrasts with the withered stalks of willow that hang over Ophelia's head in such an ominous way. The red breast of the robin perched on the tree branch, said to be a symbol of the blood of Christ's passion, shows that the dying girl is assured of salvation.

Three years after Millais completed *Ophelia,* he made a drawing entitled *The Lady of Shalott.* Here the woman is lying in a tiny boat with the ends of her long hair trailing on the river surface. A flock of cygnets contrasts with the single swan painted in the foreground. The swan as a symbol of the woman's death is found in Tennyson's 1832 version of the poem, and illustrated in Rossetti's wood-block print of 1857 and Arthur Hughes's painting of around 1862.

The length at which we have discussed just a few paintings may seem excessive, but no explanatory material should really be necessary to appreciate the paintings in this book. It is fine if you just enjoy the many representations

of women and water collected here. Many of the women are fairies, sirens, or mermaids who try to seduce men and drag them under the water, but there are also enchantresses, innocents, ruined women, unfortunates, women who drown themselves, and the pagan goddess Venus. The subject matter is taken from the writings of Tennyson and Shakespeare, from Greek epic and Roman myth, and Arthurian legend, and from aspects of Victorian society. For reference, I have given examples where necessary from similar works from European countries other than England. The common theme is water, and amid the eternal flow there is water that creates the next generation and water connected with the world of the senses and of decadence. Water, woman, love, and death—these are the common themes of nineteenth-century Romanticism. Together they culminate in Wagner's opera *Tristan and Isolde,* but as that is a large subject in itself, I will do no more than mention it.

Why is it that these motifs simultaneously became so popular around the end of the nineteenth century? In literary or art history, all sorts of things are conveniently summed up by the term *Romanticism.* During the course of the Industrial Revolution, beginning in the late eighteenth century, it began to become clear that the benefits of mechanization did not tell the whole story, that industrialization brought about evils as well. Overcrowding, poverty, unhygienic conditions, child labor, crime, the sinister murders by Jack the Ripper—the more the negative sides of urbanization became apparent, the more many artists fled reality in search of a distant, medieval past, an imagined world of myth and legend, a world of dark night and death, or a supernatural world. This was what gave rise to Romanticism and Medievalism in the nineteenth century. Amidst all of this, the motif of the death of a woman carried along by the flow of water was one that struck a responsive chord. Paintings of the beautiful death of a young girl were widely appreciated among the fin de siècle generation troubled spiritually by the development of industrial capitalism.

This may have something to do with how women were perceived at the time, since the nineteenth century is regarded as a period when sexual

discrimination between men and women worsened. As a result of the Industrial Revolution, men worked outside the home, while women were tied to the household and looked after husband and children. The following stanza from Tennyson's 1848 "Princess" makes clear how men and women were viewed.

> *Man for the field and woman for the hearth:*
> *Man for the sword and for the needle she:*
> *Man with the head and woman with the heart:*
> *Man to command and woman to obey;*
> *All else confusion.*

The Lady of Shalott's desire for Lancelot and dissatisfaction with her lot is in defiance of these contemporary social attitudes. As she is cursed and doomed to die, we can almost hear men contemptuously call her a shameful creature. Despite all the high ideals, in most cases, the ultimate fate of Victorian women who could not marry was extremely pitiful. There was little a ruined young woman could do but jump into a river, as the poet Thomas Hood described in "The Bridge of Sighs." The engraving by Gustave Doré (page 28) and *Past and Present No. 3* (page 31) by Augustus Egg, both included in this book, are examples of illustrations that deal with this social problem, for there seemed to be no end to the number of young women who committed suicide by jumping off Waterloo Bridge. One might imagine that this artwork reflected a dark interest in death unique to the Victorian period, at the turn of the century, yet this oversimplification does not explain the more fundamental question about the relation between water and women. As we again come to the end of a century, this is certainly a question that confronts us today.

PAINTINGS AND ILLUSTRATIONS

1. OPHELIA
Arthur Hughes (1832–1915)
City of Manchester Art Galleries, Manchester
1852
27$^{1}/_{2}$ x 49$^{1}/_{2}$ inches

2. OPHELIA—AND HE WILL NOT COME BACK AGAIN
Arthur Hughes (1832–1915)
Toledo Museum of Art, Toledo, Ohio
1865
38 x 23$^{1}/_{2}$ inches

3. OPHELIA
John William Waterhouse (1849–1917)
Private Collection
1894
50 x 29$^{1}/_{2}$ inches

4. OPHELIA
George Frederic Watts (1817–1904)
Trustees of the Watts Gallery, Compton
1880
30$^{1}/_{2}$ x 25 inches

5. OPHELIA
John Everett Millais (1829–1896)
Tate Gallery, London
1851–1852
30$^{1}/_{2}$ x 45 inches

6. THE DEATH OF OPHELIA
Eugène Delacroix (1798–1863)
Musée de Louvre, Paris
1844
9 x 12 inches

7. OPHELIA
Paul Steck (d. 1924)
Musées de la Ville de Paris, Paris
1890
65 x 39$^{1}/_{2}$ inches

8. ELAINE
Gustave Doré (1832–1883)
Professor Toshiyuki Takamiya, Tokyo
1868
9$^{1}/_{2}$ x 7$^{1}/_{2}$ inches

9. ELAINE
John Atkinson Grimshaw (1836–1893)
Private Collection
1877
33 x 49 inches

10. THE LADY OF SHALOTT
John William Waterhouse (1849–1917)
Tate Gallery, London
1888
61 x 80 inches

11. THE LADY OF SHALOTT
John Atkinson Grimshaw (1836–1893)
Private Collection
1878
33 x 49 inches

12. LA JEUNE MARTYRE
Paul Delaroche (1797–1856)
Musée de Louvre, Paris
1855
68 x 59 inches

13. THE BRIDGE OF SIGHS
Gustave Doré (1832–1883)
Professor Toshiyuki Takamiya, Tokyo
1878
10 x 7¹/₂ inches

14. PAST AND PRESENT NO. 3
Augustus Egg (1816–1863)
Tate Gallery, London
1858
25¹/₂ x 30¹/₂ inches

15. MIRANDA—THE TEMPEST
John William Waterhouse (1849–1917)
Private Collection, © Sotheby's
1916
39 x 54¹/₂ inches

16. HYLAS AND THE NYMPHS
John William Waterhouse (1849–1917)
City of Manchester Art Galleries, Manchester
1896
39 x 65 inches

17. THE BEGUILING OF MERLIN
Edward Burne-Jones (1833–1898)
Lady Lever Art Gallery, Port Sunlight
1874
74¹/₂ x 44¹/₂ inches

18. STUDY FOR NYMPHS FINDING
THE HEAD OF ORPHEUS
John William Waterhouse (1849–1917)
Private Collection
1900
39 x 41¹/₂ inches

19. ECHO AND NARCISSUS
John William Waterhouse (1849–1917)
Walker Art Gallery, Liverpool
1903
43¹/₂ x 75¹/₂ inches

20. THE DANAÏDES
John William Waterhouse (1849–1917)
Private Collection, © Christie's New York
1904
62 x 44¹/₂ inches

21. KELPIE
Herbert James Draper (1864–1920)
Lady Lever Art Gallery, Port Sunlight
1913
54 x 77 inches

22. CIRCE AND SCYLLA
John Melhuish Strudwick (1849–1937)
Sudley Art Gallery, Liverpool
1886
40 x 28 inches

23. CIRCE INVIDIOSA
John William Waterhouse (1849–1917)
Art Gallery of South Australia, Adelaide
1892
72 x 35 inches

24. MEDUSA
Lévy-Dhurmer (d. 1953)
Musée d'Orsay, Paris
1897
23¹/₂ x 16 inches

25. WATERSNAKES
Gustav Klimt (1862–1918)
Österreichische Galerie, Wien
1904–1907
20 x 8 inches

26. GOLDFISH
Gustav Klimt (1862–1918)
Kunstmuseum Solothurn (Dubi-Muller Foundation),
 Solothurn
1901–1902
72$^{1}/_{2}$ x 26$^{1}/_{2}$ inches

27. THE MERMAID
John William Waterhouse (1849–1917)
Royal Academy of Arts, London
1901
39 x 27 inches

28. CALM SEA
Arnold Böcklin (1872–1901)
Kunstmuseum, Bern
1887
41 x 60 inches

29. THE DEPTH OF SEA
Edward Burne-Jones (1833–1898)
The Fogg Art Museum, Harvard University, Cambridge
1887
68 x 30 inches

30. THE SIREN
John William Waterhouse (1849–1917)
Private Collection, © Sotheby's
1900
32$^{1}/_{2}$ x 21 inches

31. STUDY FOR THE SIRENS
Edward Burne-Jones (1833–1898)
National Gallery of South Africa, Cape Town
1875
67$^{1}/_{2}$ x 93$^{1}/_{2}$ inches

32. ULYSSES AND THE SIRENS
John William Waterhouse (1849–1917)
National Gallery of Victoria, Melbourne
1891
39$^{1}/_{2}$ x 80$^{1}/_{2}$ inches

33. ULYSSES AND THE SIRENS
Herbert James Draper (1864–1920)
Ferens Art Gallery, Hull
1909
71 x 85$^{1}/_{2}$ inches

34. THE FISHERMAN AND THE SIREN
Frederick Lord Leighton (1830–1896)
City of Bristol Art Gallery, Bristol
1858
26$^{1}/_{2}$ x 19$^{1}/_{2}$ inches

35. SYRINX
Arthur Hacker (1858–1919)
City of Manchester Art Galleries, Manchester
1892
77 x 24$^{1}/_{2}$ inches

36. PERSEUS AND ANDROMEDA
Frederick Lord Leighton (1830–1896)
Walker Art Gallery, Liverpool
1891
94 x 51$^{1}/_{2}$ inches

37. A WATER BABY
Herbert James Draper (1864–1920)
City of Manchester Art Galleries, Manchester
1900
27^1/$_2$ inches

38. THE LAMENT FOR ICARUS
Herbert James Draper (1864–1920)
Tate Gallery, London
1898
73 x 62^1/$_2$ inches

39. COME UNTO THESE YELLOW SANDS
Richard Dadd (1817–1886)
Private Collection
1842
22^1/$_2$ x 31 inches

40. THE BIRTH OF VENUS
Alexandre Cabanel (1823–1889)
Musée d'Orsay, Paris
1863
52 x 90 inches

41. THE BIRTH OF VENUS
Charles Shannon (1863–1937)
Aberdeeen Art Gallery and Museums, Aberdeen
1923
42 x 43 inches

42. THE BIRTH OF VENUS
William Bouguereau (1825–1905)
Musée d'Orsay, Paris
1879
120 x 87 inches

43. THE MIRROR OF VENUS
Edward Burne-Jones (1833–1898)
Museu Gulbenkian, Lisbon
1898
48 x 80 inches

44. FROM THE DEEP WATERS
Toshiyuki Takamiya (1866–1943)
1906
7 x 4^1/$_2$ inches